Mastering Aperture, Shutter Speed, ISO and Exposure:
How They Interact and Affect Each Other

By Al Judge

Sedona, Arizona

Copyright © 2012 by Al Judge

Introduction

The most basic definition of Photography is recording how light is reflected from an object or scene. There are also more artistically oriented definitions, such as:

Photography records the gamut of feelings written on the human face, the beauty of the earth and skies that man has inherited, and the wealth and confusion man has created. It is a major force in explaining man to man.

— Edward Steichen

Regardless of how you see photography and its purpose, you will still need to understand **Exposure** and its components **Aperture**, **Shutter Speed**, and **ISO** – also known as the ***Exposure Triangle*** – if you want to have any control over your results.

The fact that you are reading this book suggests that you have made a commitment to getting the most out of your camera. I commend you for making that decision and will do my best to save you from the frustration and confusion that most people experience.

Some Definitions

Before we do anything else, I thought it might be a good idea to define some terms that are used throughout this book. They will be discussed and defined in more detail as we progress, but I just want to make sure that we have a solid foundation for clear communication. I have not listed these terms in alphabetical order, but rather in the order of relative importance. Terms that seem to confuse and intimidate most people are at the top of the list.

Aperture – A hole or opening through which light travels.

Diaphragm – An adjustable mechanism similar to the iris of the human eye that provides a way of changing the size of the aperture of a camera.

f-stops – Standardized aperture settings. Focal Length (f) / Aperture Diameter.

Depth of Field – The amount of the image that is in sharp focus.

ISO (International Standardization Organization) – A measure of light sensitivity in film and in digital camera sensors. Adjusting ISO has no affect upon the light that enters the camera or that the sensor or film sees. It merely changes the light sensitivity of the sensor or film.

Exposure – The total amount of light that the film or sensor sees.

In-Camera Exposure Meter – A device built into the camera that measures light reflected from the scene being photographed.

Exposure Compensation – A way to fine tune the camera's exposure meter.

EV – Exposure Value – A unit of measurement used by light meters and by the Exposure Compensation function of digital cameras.

Proper Exposure – The amount of light necessary to produce a clear and vibrant image.

Histogram – A graph composed of 256 vertical bars used to evaluate exposure. The farthest left bar represents BLACK, the farthest right bar represents WHITE, and the rest represent shades of grey in Black & White photography or Tonal Values in Color Photography. The height of any bar is determined by the percentage of the overall image that has the same shade of grey or Tonal Value. The bars blend in such a way that the appearance is a smooth graph.

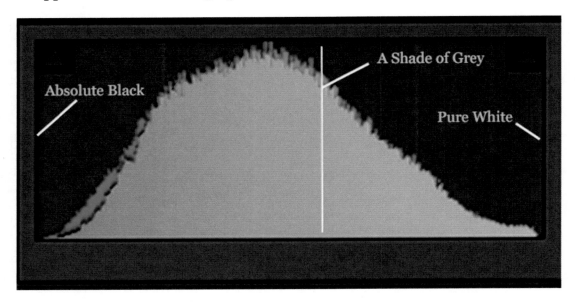

Shutter – A mechanical device that covers the sensor or film except when they are exposed to light. Some newer digital cameras have electronic Shutters for faster Shutter Speeds.

Shutter Speed – The amount of time that the shutter is held open in order to expose the film or sensor to light.

Sensor – The digital equivalent of film. An electronic device capable of recording visual data.

SLR camera – A camera with changeable lenses in which the viewfinder image is identical to the image that the sensor sees. It must also be based on the 35mm film camera model. We will talk about this in some detail later in the book with visual aids.

DSLR – A digital SLR camera.

Neutral Grey Card – A grey card with 18% reflectance that is used as a color calibration device for digital cameras. Also referred to as 18% grey card, white balance card, or median grey card.

Lens – Surprisingly, this can be a point of confusion since it can refer to a single piece of glass or a camera lens assembly that consists of several pieces of glass, as well as the aperture, and electronic and mechanical mechanisms. In this book, lens will mean the lens assembly unless we are talking about optical principles. In this case, it is much easier to understand the principles if the lens is imagined as a single piece of glass.

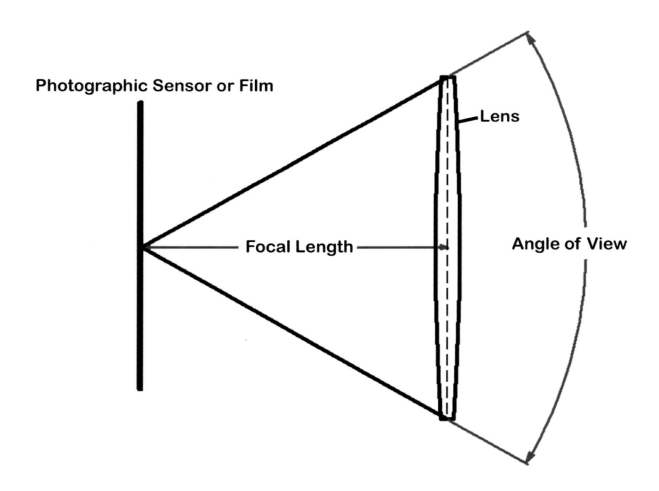

Focal Length – *f* – the distance from the mid-plane of a lens to the point of sharp focus when the lens is focused to infinity. Focal Length is expressed in millimeters (mm).

***Field of View or View Angle* –** The angle that is defines the image based on the location of the camera. It can be measured horizontally, vertically, or diagonally. If measured diagonally, human vision is about 48 degrees. Camera lenses range from a few degrees to about 120 degrees diagonally. The FOV (Field of View) is what is seen through the viewfinder at any moment in time.

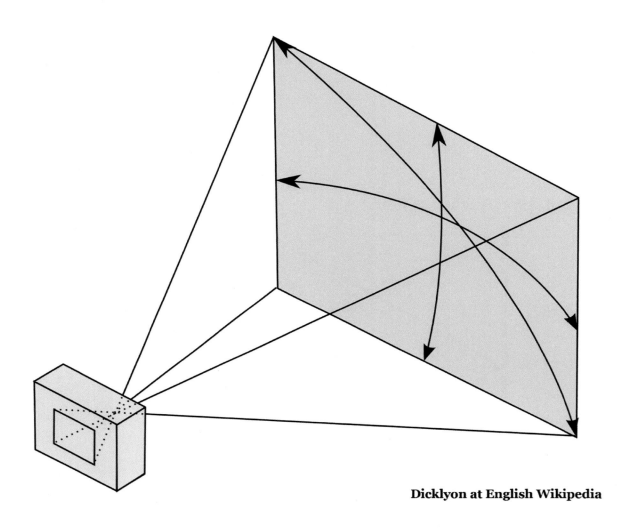

Dicklyon at English Wikipedia

Wide-Angle Lens – A lens that has a view angle that is larger than human vision. The image in the viewfinder has the appearance of having moved backwards. Up to about 120 degrees diagonally.

Telephoto Lens – A lens that has a very narrow view angle. It compresses distance and acts like a magnifying glass. Angles can be in the range of 8 degrees diagonally.

Zoom Lens – A camera lens that can be zoomed in or out to more precisely frame the image.

Basic Zone Modes – Fully automatic camera modes such as Portrait, Landscape, Sports, etc.

Creative Modes – Camera modes that give more control to the photographer.

Av Mode – Aperture Value Mode or Aperture Preferred Mode. A popular creative mode in which you set the f-stop (aperture size) and the camera selects a Shutter Speed based on the camera's exposure meter reading. Used when Depth of Field is most important.

Tv Mode – Time Value Mode or Time Preferred Mode. Another popular creative mode in which you select the Shutter Speed and the camera selects the Aperture Value (*f*-stop) based on the camera's exposure meter reading. Used when freezing the action or motion blur is desired.

Manual Mode – The photographer selects all settings.

Let's Talk Millimeters – mm

Throughout this book and any other one dealing with photography, you will often see measurements expressed in millimeters – terms like 35 mm, 18 mm, 50 mm, 100mm, etc.

When I got my first 35 mm film camera, I wondered why I needed a 50 mm lens for a 35 mm camera and why my lens cap was 58 mm. I soon learned that these measurements refer to different aspects of the camera.

My camera was 35 mm because it used 35 mm still photography film.
My lens was 50 mm because it had a 50mm Focal Length.
My photo filters were 58 mm because of the size of the threads that allowed them to be screwed to the front of my lenses.

Another reason for my confusion was the fact that many photographic references are to things that we don't see, such as Focal Length and Sensor Size. Though it is not critical to our discussion of the ***Exposure Triangle***, it might be worthwhile to take a minute and talk about this topic in some detail.

Film

Let's start with film. 35 mm has been the standard size for *movie* film since 1909. It has only been since 2008 that 35 mm movie projectors have started to be replaced by digital projectors that require no film – just a digital file.

There have been numerous sizes of *still* film for consumer cameras and large format professional cameras, but none as popular as 35 mm film. Much of its popularity came from the fact that it was widely accepted as the best value when considering both price and performance.

In the 1950's, some Japanese companies began manufacturing 35 mm SLR cameras. We will be talking more about SLR cameras in the chapters that follow, but for now the important point is that the 35 mm SLR camera became the *camera of choice* for professionals and high-end consumers. The 35 mm camera got its name from the 35 mm film that it used.

Sensors

Digital cameras began to show up around 1989, but the first Digital SLR from a major manufacturer didn't come until 1999. It was the Nikon D1.

Digital SLR cameras have electronic Sensors that eliminate the need for film. A *Full-Frame* DSLR has a sensor that is roughly the size of a frame of 35 mm film. The standard for Full-Frame Sensors is 36 mm X 24 mm – approximately 1.5 in X 1.0 in. *Cropped-Frame* sensors in lower cost DSLR cameras are smaller than the Full-Frame Sensors but much larger than the Sensors in point-and-shoot cameras.

Though the Sensor sizes currently available are changing constantly, a few ballpark numbers might help with perspective. When it comes to sensors, we are concerned with area – Width X Height.

Full-Frame Sensor	864	sq mm
Cropped-Frame Sensor	329 to 548	sq mm
Point–and–Shoot	24 to 43	sq mm

In general, the larger the Sensor, the better the performance.

In the following image, the camera on the right is a Full-Frame Camera and the one on the left is a Cropped-Frame model. The sensor is the rectangle in the center of each opening.

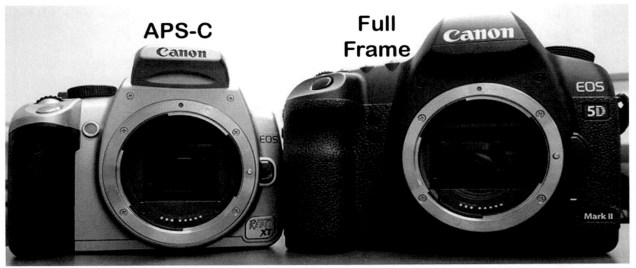

Full Frame

BLUE BOX Canon APS-H
RED BOX Canon APS-C

Lenses

Camera Lenses are generally classified by *Focal Length* and *Maximum Aperture Size* – two topics that we will be talking about in detail later in the book. For now, you just need to know that a 50 mm lens is one that has a *fixed*-focal length of 50 mm (roughly 2 inches). A 70 mm – 250 mm lens is a Zoom Lens that has a *variable* focal length ranging from 70 mm to 250 mm.

Lens Filters

Filters screw onto the front of a camera lens and modify the light entering the lens. There are a number of important types of filters, but the important point here is that a 58 mm filter is one that has a threaded diameter of 58 mm. Also, don't assume that all lenses that fit your camera will accept the same size filter. I have three lenses. Two of them take 58 mm filters. The third one takes a 52 mm filter. Rather than buy extra

filters, I purchased an inexpensive adaptor ring that allows me to use my 58 mm filters on the lens designed for 52 mm filters.

I hope that this brief overview will take some of the confusion out of the mm references as we move forward.

A Personal Point of View

When I got my first 35 mm film camera nearly 35 years ago, I was totally intimidated by the *f*-stops and wondered if I would ever really know how to adjust my camera. For a while, I just did what photography books told me to do and hoped for the best. After a while, I knew what settings worked from experience more than from understanding the underlying principles. I don't recall ever really "getting it" until I moved to digital photography.

Although Shutter Speed made a lot more sense to me than *f*-stops, I was always a little insecure about setting my Exposure. Most serious photographers used light meters which exceeded my budget at the time, so I winged it. Overall I had some pretty good results, but it was a long time before I had any confidence in what I was doing behind the lens.

My hope is to spare you the confusion and frustration that I experienced early in my photographic endeavors. Photography should be fun. The more you enjoy it, the better you will become at creating images that convey feelings as well as facts.

As technology has advanced, the cost of digital cameras has dropped dramatically. The result is that many people are walking around with expensive cameras that intimidate them. They use the automatic modes and basically have an expensive and powerful point-and-shoot camera. The other thing that I often see is the "spray & pray" approach to photography – the old belief, that if you take enough pictures you will eventually get some really good ones. With this approach, you may get some pretty good images but they will never be in a class with the images of a photographer who understands his equipment and its capabilities.

Having a great camera is not enough. You need to develop mastery over its settings if you want to produce great images. Do yourself a favor and forget that auto modes such as portrait and landscape even exist. They will only hold you back. They may have produced images that received rave reviews, but they are your enemy if you want to be an accomplished photographer. Auto modes stop you from thinking and learning. Anyone can point and shoot. You want to do more. You want to use the camera as a means of expression, and you can't do that if all the decisions have already been made by the camera's software.

Taking Control

Deciding where to start with the **CREATIVE SHOOTING MODES** may be a personal preference, but your three best options are: Av (Aperture Value), Tv (Time Value), and Manual (you set everything). I placed these modes in this order because this progression will work best for most people in their learning process. Av is the mode most often used by professionals. Even those who prefer the manual mode often use Av to get them in the ballpark. With Av, you set the Aperture and the camera selects the Shutter Speed that will produce a properly exposed image. By the time you finish reading this book, you will understand how inadequate that approach can be. But the fact remains that the camera will make a pretty good guess at the Shutter Speed. You can then use that data to help you optimize your settings.

With the Tv mode, you choose the Shutter Speed and the camera will choose the Aperture Setting (*f*-stop). As with the Av mode, this might be a good starting point, but not your ultimate choice.

I have placed Av as the first mode because understanding the aperture setting is critical to controlling exposure, depth of field, and the photographer's ability to convey a feeling or mood. It is also the most intimidating photographic topic for most people.

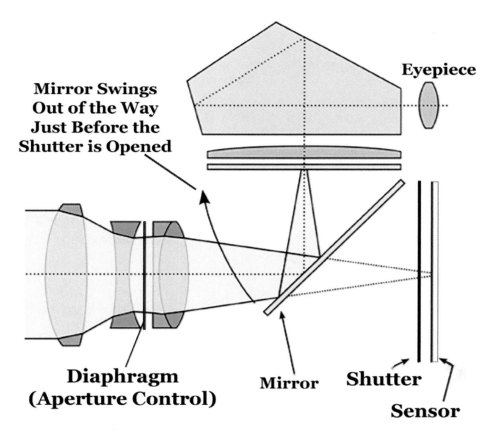

Wikipedia Commons Image - Modified by Al Judge

Let's start with the basics: Light from an object or scene passes through a hole that can be varied in size – the **APERTURE** – and must strike the Sensor in order to be recorded as a digital image. As light passes through the lens, it forms an image at a focal length that matches the sensor location (focal length will be discussed in the next chapter). Prior to activating the shutter release (pushing a button on the camera body), a mirror reflects the same image to the eyepiece in order to focus and frame the image. When the Shutter Release is activated, the mirror moves out of the way, the shutter opens, and the sensor or film is flooded with light for some period of time. The shutter then closes, the mirror snaps back into place, and the camera is ready to capture another image.

The shutter lies between the aperture and sensor and controls how long the light is allowed to strike the sensor in order to form the image. If the shutter stays open too long, we say that the image is **_overexposed_**. If the shutter closes too soon, we say that the image is **_underexposed_**.

Even though the shutter plays a very critical role in achieving a quality image, the aperture has already determined some characteristics of the final result before the shutter is ever activated. The size of the Aperture opening is called an "**_f_-stop**." The name comes from its relationship to the focal length of the lens.

The important thing to know about _f_-stops is that the higher the number, the smaller the opening that the image must pass through. Also, a very small hole produces a very sharp image and a larger hole produces a softer image. For this reason, landscapes are associated with high _f_-stops and portraits are associated with low _f_-stops.

Another aspect of the Aperture setting is **DEPTH OF FIELD**. A shallow depth of field means that the subject of the image is in focus but the background is blurred; "Gaussian blur" is a commonly used term for this effect. A large depth of field means that the image is in sharp focus from foreground-to-background. Portraits look best with a shallow depth of field and landscapes look best with a large depth of field.

There are no standards for the minimum and maximum _f_-stop value for any specific lens. In fact, a zoom lens will have different min and max values depending upon the focal length being used (how much it is being zoomed in or out).

Much of this introduction will be repeated in the chapters that follow. This is intentional. The more often you are exposed to something, the more likely you are to retain it. Some things in photography just bear repeating.

Aperture, Shutter Speed, and ISO all have an affect on Exposure and each other. In order to simplify our discussion, I will first cover each one in detail, and then explain how they are adjusted for optimum results. I will also give some real-life examples to help clarify the finer points.

Chapter One – Understanding ISO

Aperture, Shutter Speed, and ISO are often referred to as the ***Exposure Triangle*** because these three settings control the total amount of ***exposure*** that the sensor or film sees. I have decided to start our detailed discussion with ISO so that we can put it aside and deal with the more challenging adjustments of Aperture and Shutter Speed.

Adjusting ISO has no direct affect upon the light that enters the camera or that the sensor or film sees. It merely changes the light sensitivity of the sensor or film.

ISO affects the amount of light indirectly by requiring more or less light to achieve proper exposure. This in turn requires a change of Aperture, Shutter Speed, or both.

Although the ability to change the ISO is very important, it is not something that you do every day. My camera is set on ISO 100 or ISO 200 (the slowest setting for some lenses) 95% of the time. I only change it as a last resort or when I am certain that it is needed. For example, if I am trying to capture images of lightning, I will just set it to ISO 800 as a starting point. With experience you will quickly get a feel for when a change of ISO is justified.

The ISO value was originally developed to identify the light sensitivity of various types of film. The basic or slowest film was set at ISO 100. A film that was twice as sensitive to light would then be ISO 200. A film that was twice as sensitive to light as ISO 200 was ISO 400, and so on. In this way, if you used a film that was twice as sensitive to light, you could achieve the same exposure by reducing the *f*-stop by a full stop or cutting the exposure time in half. This allows greater latitude in depth of field under low light conditions.

The main drawback to high-ISO film is that the image has a grainy appearance when developed. The larger the print, the more noticeable the grain. Oddly enough, this effect has carried over to digital photography. ISO settings on a digital camera adjust the light sensitivity of the sensor in a way that simulates the ISO ratings of film. Because of the increased sensitivity, the sensor is more prone to **NOISE** (unwanted electrical signals and heat), thus creating a similar grainy effect. The larger the sensor, the less it heats up and, therefore, the less noise it creates.

Most digital SLR's have built-in filters to reduce the noise effects from increased ISO and long exposures. When you use these filters, the image is processed immediately after it is taken. If you have a 60-second exposure, it will take the camera an additional

60 seconds to process your image before it is visible on you camera's monitor. You cannot take another photo until the process is over. The time to filter the image is not an exact one-to-one ratio, but my experience has been that it is pretty close. So a one-minute exposure might not take exactly one minute to filter but it will be very close to that value.

Thirty years ago when I was doing film photography, you had to change film in order to change ISO. That meant wasted film and time as well as having to carry a number of extra rolls of film to cover different situations. Even though ISO 100 gave the best results for landscapes, I normally shot with ISO 400 so that I could cover a wider range of lighting situations without having to waste film. Although there is definitely a grainy effect in ISO 400 film, it is not that significant and in some cases actually enhances the effect.

I always carried a roll of ISO 1600 film just in case a situation presented itself. On a trip to British Columbia I visited a rain forest. It was a beautiful sunny day but the rain forest was so dark that even with ISO 1600 film I had to take long exposers. Unfortunately, at that time, I wasn't using a tripod and had to find flat places to position the camera for using the remote shutter release. I think of this experience every time I have to change ISO on my digital camera. No hassle, no wasted film, no wasted time, nothing extra to buy or carry. I love it!

Chapter Two – Understanding Aperture

Aperture

In its most basic definition, **APERTURE** simply means a hole through which light travels. As far back as 500 BC people in China were commenting on the fact that light passing through a small hole in a piece of fabric or through a wicker basket sometimes produced an inverted image on another surface. Discussion of this phenomenon continued throughout history and led to the first "pinhole" camera in 1850 created by Scottish Scientist Sir David Brewster.

To learn more about the history and evolution of Pinhole Cameras check out
http://en.wikipedia.org/wiki/Pinhole_camera

Pinhole Cameras – Back to Basics

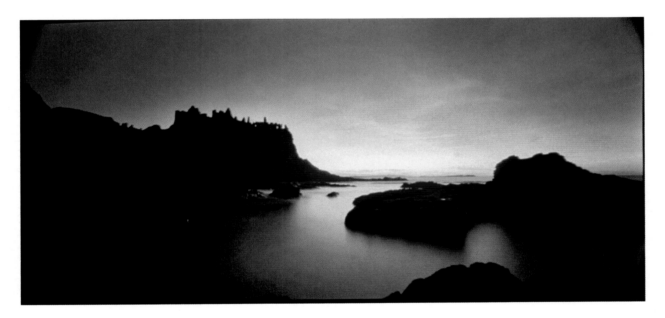

The image above was taken by Ewan McGregor and appears on the Wikipedia page related to the link above. It is the result of a twenty-minute exposure with a pinhole camera.

Most people are surprised to learn that a camera doesn't require a lens – just a small hole – in order to capture an image. They are even more surprised to learn that pinhole cameras are more than just a rudimentary camera. They can produce extremely sharp images and they still have a place in modern photography. We will get back to that point a little later, but first let's talk about what happens when light passes through a hole. If you understand this, you will be in a better position to master the more subtle aspects of creative photography.

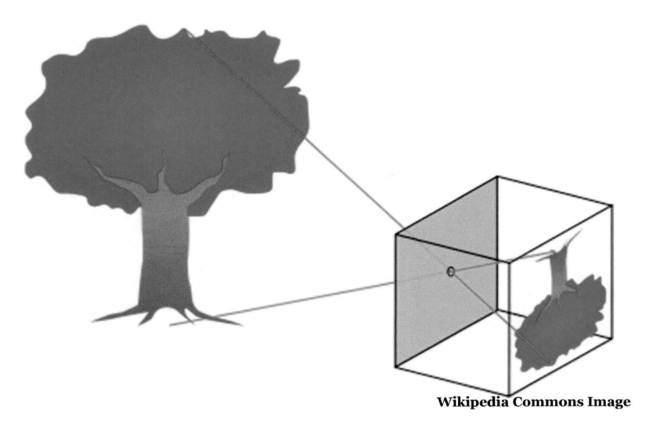

As illustrated in the image above, when light passes through a small hole, it produces an inverted image on a surface at some distance from the hole. The image is inverted because light travels in straight lines. The light passing through the pinhole is reflected light. When sunlight hits a point on a leaf at the top of the tree, the surface of the leaf will absorb some of the light and reflect the rest away from it. Some of that reflected light then passes through the pinhole in a straight line from the point on the leaf and strikes the surface at the back of the box. As illustrated above, points on the top of the tree will be projected to the bottom of the box and points at the bottom will be projected to the top. This results in an inverted image on the back of the box. If a digital sensor or piece of film is placed at the back of the box, the image can be recorded. The color of the image will be determined by the light that is NOT absorbed by the object. This fact will be important to our discussion of **EXPOSURE** later in the book.

The illustration above offers some additional lessons. When a ray of light enters the box, some of its energy will be absorbed by the surface that it strikes. The light energy that is not absorbed by the film or sensor is free to bounce around the box like a ball. This additional light causes some blurring of the otherwise crisp image. As you might expect, the less light that we let into the box, the sharper the image will be, but we still need to let in enough light to create a bright image. Controlling the total amount of light that passes through the pinhole is the job of the shutter and will be discussed in more detail when we discuss **SHUTTER SPEED** later in the book.

There is another factor that affects the sharpness of the image. It is the thickness of the material around the pinhole. The figure below demonstrates what happens when a beam of light strikes the sides of the hole. The light bounces off the sides and blurs the

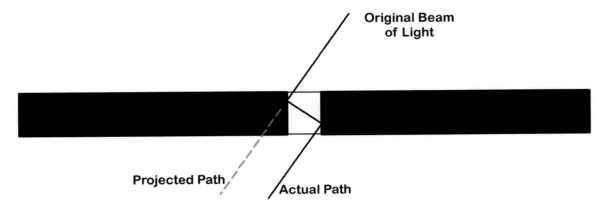

image since it strikes the back of the box at a position that is slightly offset from where it would have hit if the plate were thinner The light bouncing around in the hole also diffuses rays of light that would ordinarily pass through the hole without striking the sides. Thus, the thinner the material surrounding the pinhole, the sharper the image.

Next, let's look at what happens when the hole or **Aperture** gets larger. Rays of light that pass through the Aperture perpendicular to the Sensor or Film (Black Lines) create a sharp image, while rays of light that enter at an angle (Red Lines) bounce around the enclosure and blur the image.

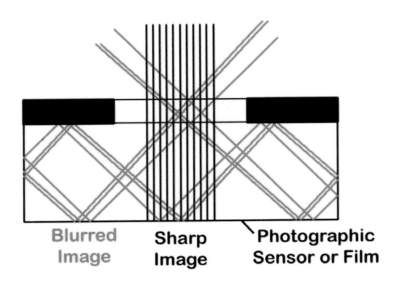

DEPTH OF FIELD is a photographic term that indicates how much of the image is sharp and how much is blurred. We will be talking more about this later, with some examples to illustrate the concept. The important thing to remember here is that most of the light striking the sensor will be like the black lines when the aperture is small and like the red lines when the aperture is large.

The distance from the pinhole to the back of the box determines how much of the scene in front of the camera can be recorded on the sensor or film. When the back of the chamber is close to the pinhole it acts like a wide-angle lens and when the back of the chamber is far away it acts like a telephoto lens. The distance from pinhole to sensor is analogous to the focal length of lenses.

Before we move on to Focal Length, let's take a moment to reflect on what we have learned from Pinhole Photography.
- You don't need a lens to take a photograph.
- Small Apertures produce sharp images.
- Large Apertures produce images with blurred areas.

Earlier I mentioned that Pinhole Cameras are more than a curiosity. They are great for security cameras and surveillance since they are virtually impossible to detect.

NASA wants to build an enormous version of the Pinhole Camera to capture images of distant galaxies.

Focal Length

Before we discuss how to adjust your aperture, we need to talk about **FOCAL LENGTH**. Focal Length is the distance from the mid-plane of a lens to the camera's sensor or film.

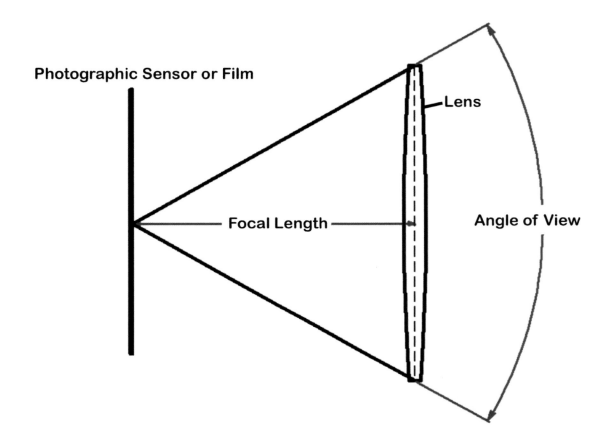

The Focal Length determines how much of the scene in front of the camera can be captured by the sensor.

The following diagram shows the relationship between focal length and angle of view for three different lenses – an 18 mm Wide-Angle Lens, a 50 mm Normal Lens, and a 228 mm Telephoto lens. The second image shows the effects in real life for various focal lengths.

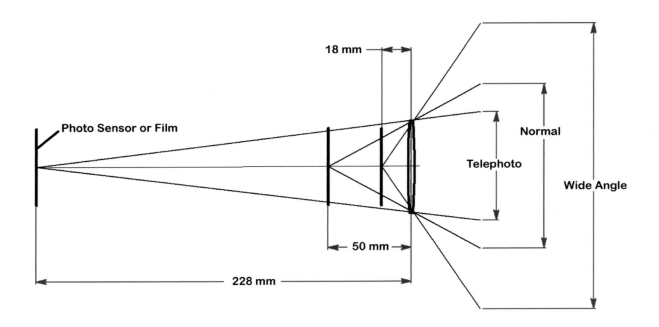

As you can see in the following image, the amount of the scene that can be captured by a wide-angle lens at 18 mm is dramatically greater than even a 35 mm focal length. This is why wide-angle lenses are so popular with landscape photographers.

The image below indicates how much of the large image you would see in your viewfinder for each focal length on the chart.

The entire image corresponds to an 18mm focal length. The focal lengths for the smaller rectangles are:

35 mm – Black Rectangle
45 mm – Larger Yellow Rectangle
65 mm – Red Rectangle
100mm – White Rectangle
250 mm – Smaller Yellow Rectangle

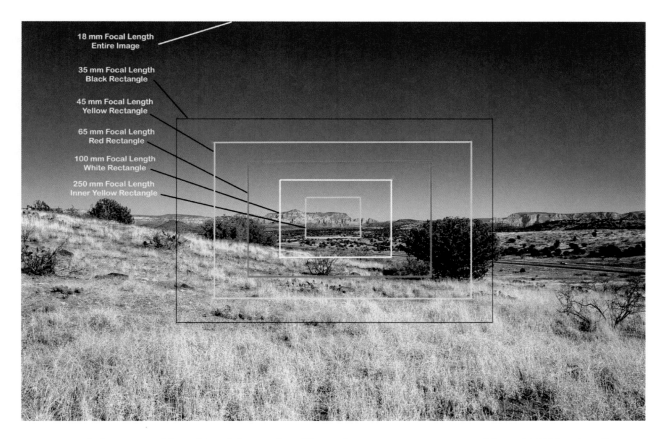

18 mm Focal Length
Entire Image

35 mm Focal Length
Black Rectangle

45 mm Focal Length
Yellow Rectangle

65 mm Focal Length
Red Rectangle

100 mm Focal Length
White Rectangle

250 mm Focal Length
Inner Yellow Rectangle

In general, lenses with a Focal Length of less than 35mm are considered Wide-Angle Lenses. Lenses that are in the 50 mm range are considered Normal and simulate human vision. Lenses that have Focal Lengths greater than 70 mm are considered Telephoto Lenses.

Wide-Angle Lenses exaggerate the size of subjects that are close and shrink objects at a distance.

Telephoto lenses act like magnifying glasses since they focus on such a limited area of the scene. They also tend to shrink distances. In some cases, objects that are miles away look like they are very close to objects that are only a few yards away.

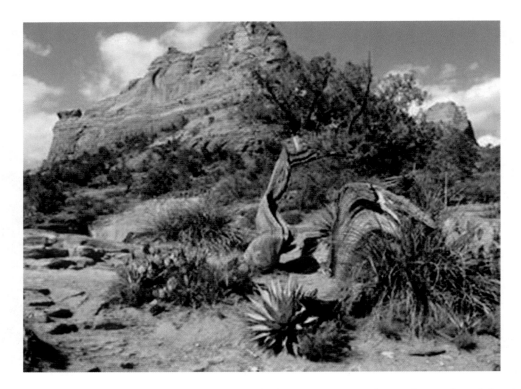

The Image above was taken with a wide-angle lens. Notice how the twisted juniper trees in the foreground stand out. Because they are close to the camera, they are somewhat magnified compared to the large red rock formation behind them.

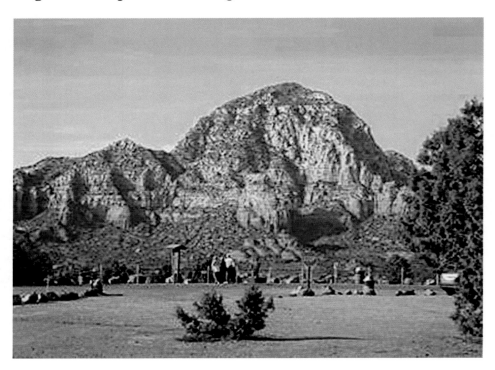

In the image above, the large rock formation is about a mile from the people but appears to be much closer. This is the result of using a telephoto lens. Besides enlarging objects, it compresses distance.

Aperture Settings – f Stops

As a result of our discussion of Pinhole Cameras and Focal Lengths, we are now in a great position to take the mystery and intimidation factor out of adjusting **APERTURE** and **DEPTH OF FIELD**.

Most people are confused by the fact that large f-stop numbers indicate small holes and vice versa. This is because an f-stop number is actually a fraction. Just as 1/10 is larger than 1/1000, so f/8 is larger than f/22. The actual meaning of the number (fraction) is:

Focal Length (f) / Diameter of the Aperture (Hole)

So if we have a lens with a Focal Length of 50 mm and the Aperture is set to an opening with a diameter of 12.5 mm, we have

50 mm / 12.5 mm = f/4

The importance of the f-stop is its affect on exposure and depth of field. When a photographer says that he has "stopped down a full stop," he means that he has reduced the area (not diameter) of the aperture opening by one-half. Therefore half as much light is allowed to pass through the aperture to the sensor. Digital SLR cameras allow you to stop up and down in ½-stop and 1/3-stop increments for greater control over Exposure and Depth of Field.

DEPTH OF FIELD is the range of sharp focus in an image. If the aperture opening is large, the image will have soft edges and the background will be blurred. This is the preferred setting for portraits where the person's face is the object and the background is unimportant. The opposite is true of landscape photography. In this case, everything from foreground to background should be in focus. All other situations fall somewhere between these extremes and an experienced photographer will quickly decide the optimum f-stop to create the feeling that she hopes to convey.

The actual f-stop settings available to you will depend upon the lens being used. If you are using a zoom lens, the Focal Length of the lens will change as you zoom in or out. The lens will have a limited number of aperture opening sizes that it can produce, and so the f-stop values available will vary as the Focal Length changes.

As you can see from the following chart, the actual size of the Aperture can vary significantly depending upon the Focal Length of the lens and the f-stop selected.

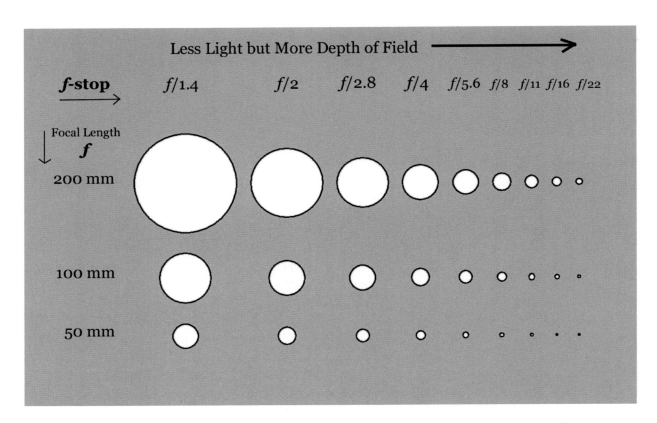

Digital SLRs also let you choose fractional stops for greater control. This selection can be made with the camera's menu selections. The following chart shows the values that will be available based on your selection.

	One Stop						Two Stops												
Full Stops	2.8			4			5.6			8			11		16			22	
1/2 Stops	2.8		3.3	4		4.8	5.6		6.7	8		9.5	11	13	16		19	22	
1/3 Stops	2.8	3.2	3.5	4	4.5	5	5.6	6.3	7.1	8	9	10	11	13	14	16	18	20	22

The full range of choices will not be available for all lenses. For any given lens, there will be a maximum and minimum Aperture value. For zoom lenses, these min and max values will change as you change focal length (zoom in and out).

Wide Apertures have small *f*-stop numbers and are preferred for portraits and close-ups of flowers and plants.

Medium Apertures often produce the best quality images when Depth of Field is not critical.

Small Apertures have large *f*-stop numbers and are preferred for landscape photography. Although the image will theoretically get sharper as the aperture gets smaller, this is not necessarily the reality. Diffraction effects cause some deterioration of the image at very small sizes. Most lenses have a minimum aperture of *f*/22 but some go to *f*/32.

Examples of Depth of Field

A shallow Depth of Field is just as desirable when photographing flowers as it is for portraits. The details of the background are unimportant but the colors often enhance the image of the flower. The image below was taken with a 50 mm lens, f/1.8, and ISO 200. This is a very large aperture setting and allowed me to have a faster shutter speed. Flowers move with even the slightest breeze and I live in a windy climate. We will talk about Shutter Speed in the next chapter, so for now I will simply state that the speed was 1/50 sec. This is actually slower than I would normally use for this type of image but it worked out ok.

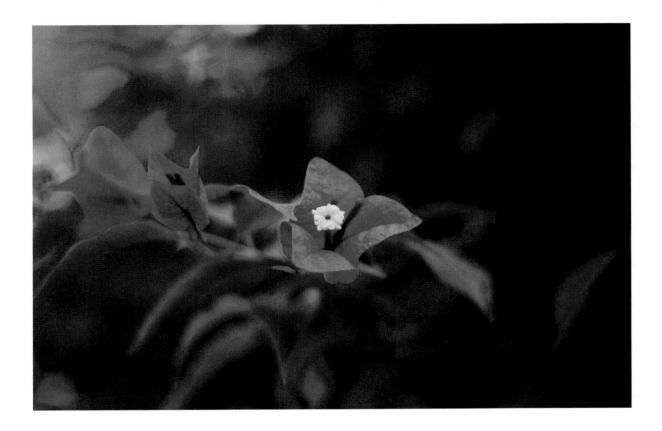

BOKEH is a term closely associated with a shallow depth of field. Basically it is the esthetic quality of the blurred background. If a lens has a good bokeh it means that the blurred background is very even in color distribution. A poor bokeh, on the other hand, is very splotchy.

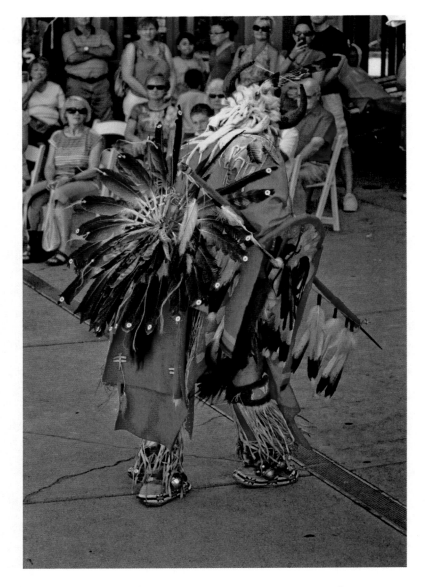

The image above was taken with settings of $f/4$, 1/500 sec, and ISO 400, at 55 mm focal length. Although f/4 is in the large aperture range, the people in the background are still a serious distraction. The dancer's movement is far too fast to use anything other than a fast Shutter Speed. For the same reason, I couldn't have used a lower f-stop – I wanted the Dancer and his costume to be sharply focused. A shallower Depth of Field might have missed some details. When this image is enlarged, you can see the reflection of the audience in the bells on his feet.

With the help of Photoshop, I was able to eliminate the audience and get the result that I was looking for.

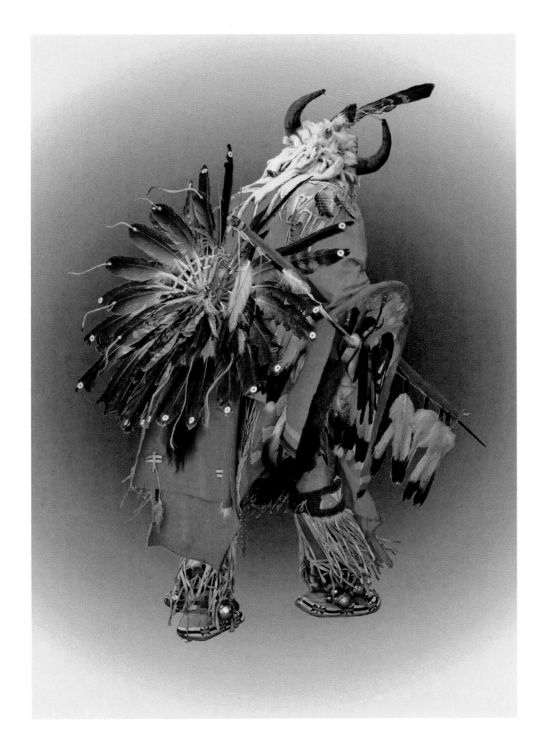

The next image is an example of a large Depth of Field.

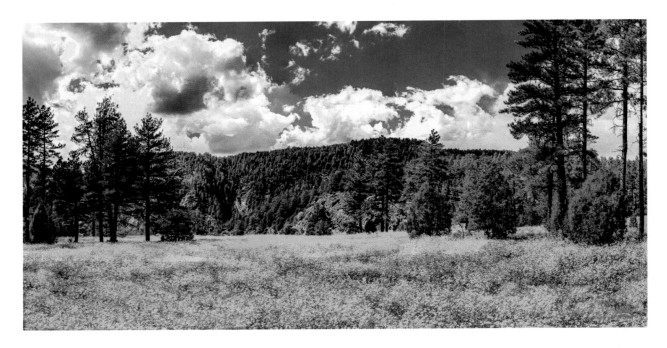

Everything is in focus from foreground to background. This is standard procedure for landscape images. The settings are $f/20$, 1/8 sec, ISO 100, and 50 mm focal length. This is actually a composite of about 25 images. The result is a field of view similar to using a wide-angle lens at about 18 mm focal length.

In order to master Aperture and Depth of Field settings, you need to understand how Aperture is affected by Shutter Speed and Exposure. So let's move on to those topics and come back to this after we have all the pieces of the puzzle lined up.

Chapter Three – Understanding Shutter Speed

Where is the Shutter?

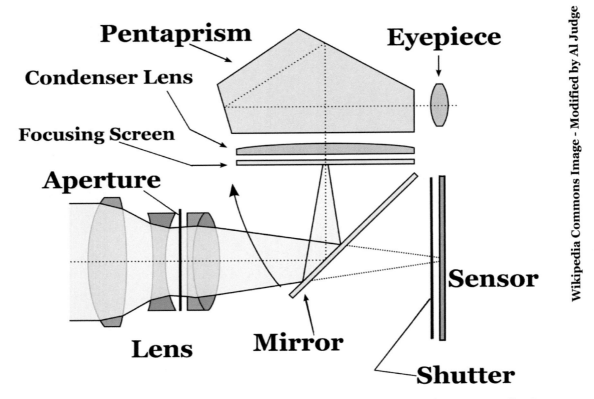

Wikipedia Commons Image - Modified by Al Judge

The Diagram above is a schematic of a generic DSLR (Digital Single Lens Reflex) camera.

Although we are concerned with Shutter **Speed**, I thought that it might be helpful to understand the shutter's physical location within the camera. This is the position for all 35 mm film cameras as well as most Digital SLR cameras. This type of Shutter is called a **Curtain** or **Focal Plane Shutter** since it is located so close to the Sensor or Focal Plane. This style of shutter can respond much faster than the Leaf shutter that is common in point-and-shoot and some high end cameras. A leaf shutter is often located in the lens mechanism between glass lenses. Some newer cameras have electronic shutters which have even faster Shutter Speeds than Curtain Shutters.

Light from the object passes through the camera lens and is focused to project a sharp image on the Sensor. Thanks to the mirror, we see the exact same image as the Sensor when we look through the eyepiece. When the shutter release button is pushed on the camera, the mirror moves out of the way, the Shutter opens and the light hits the Sensor. After some set time (Shutter Speed), the Shutter closes and the mirror returns to its original position. Most DSLR cameras allow the user to lock the mirror in the open position for extremely fast shutter speeds in order to reduce camera shake caused

by the motion of the mirror snapping back out of the way. When the mirror is in this position, you cannot see anything through the viewfinder. So set your focus and frame your shot before locking the mirror in the open position.

Notice that the Lens is actually a number of glass lenses that work together to focus the light. The Aperture is also inside the lens body but is not shown on this diagram. So as the light passes through the lens it is also being controlled by the Aperture.

Shutter Speed is important for creative control since it can dramatically change the feeling of an image. A great example of this is images of water flowing over rocks.

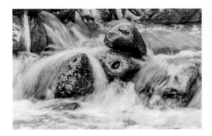 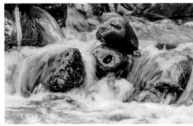 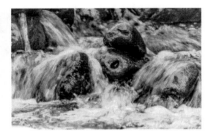

250 mm Focal Length, ISO 100, f/5.6 Shutter Speed (left to right) 1/10, 1/15, 1/30
Notice how you can see more detail in the flow of the water as the Shutter Speed increases (gets faster) from left to right.

Many people prefer a smooth velvety look for water flowing over rocks. This requires a slower shutter speed and therefore a smaller Aperture.

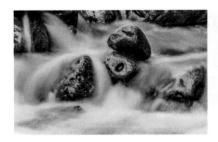 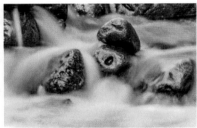 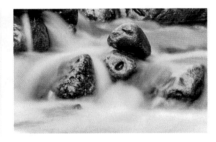

250 mm Focal Length, ISO 100, f/32 Shutter Speed (left to right) 1.3 second, 2 seconds, and 3.2 seconds.
Notice how the velvety effect increases in the flow of the water as the Shutter Speed decreases (gets slower) from left to right.

Shutter Speed can have as much or more effect on creative expression as Depth of Field.

Some Artistic Uses of Shutter Speed

To freeze action, an extremely fast shutter speed is needed. With a slower Shutter Speed the motion is blurred.

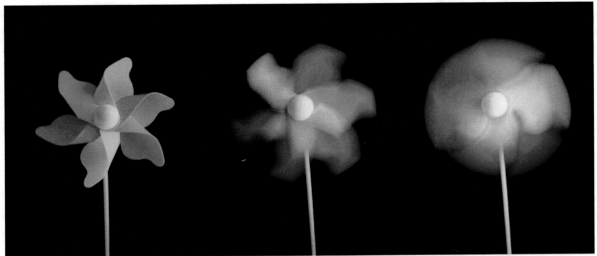

In the image above the Pinwheel on the left is frozen in time by a very high shutter speed like 1/500 or faster. The image on the right is the result of a slower speed – something less than 1/30. The image in the middle is somewhere between the two – probably 1/125.

Light Painting

This 4-second exposure is an example of light painting.

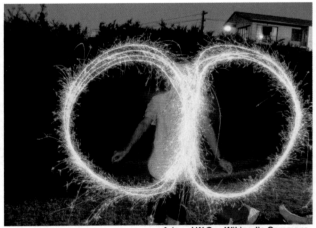

Another type of light painting is to use a flashlight to briefly illuminate an object such as a tree during a longer exposure. Another option is to write on a wall with a flashlight.

All of these techniques require a good deal of trial and error to determine the proper exposure time and light intensity.

Lightning

The best way to capture a shot of lightning is to set the Shutter Speed at 10 to 15 seconds with a small aperture. Then take repetitive shots until you get the shot you want.

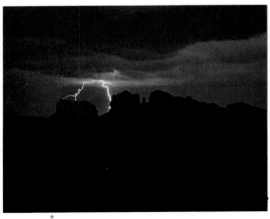

When the lightning strikes, the flash of light will be very bright and usually more than adequate to capture the action.

Trying to guess when the next flash of lightning will strike rarely produces a useable image.

A shutter timer remote control like the one shown below can be a big help in this situation and can be had for about $10.

Panning

Panning is a technique that is used with fast moving objects. The basic idea is to match the speed of the object with the movement of the camera. In other words, pick a spot on the object and try to keep the center of your frame on that spot while you take the picture. The Shutter Speed will be set to no slower than 1/30 or faster than 1/250. The faster the object is moving, the faster the shutter speed required.

This technique is typically used when the subject is moving across your view angle. The result is a photo with the subject in focus and lines of motion in the background. Race cars, motorcycles, and athletes are often the subject of these photos.

Traffic Patterns

A 30-second exposure (Shutter Speed) will show auto lights at night as lines. The lights are normally white on one side of the road and red on the opposite side. Obviously, the color is a result of whether you are looking at headlights or taillights.

City Lights at Night

An 8-second exposure like this one can produce some beautiful cityscapes at night. Stationary objects and lights will be very sharp and well lit, while moving objects and lights will produce streaks. The contrast can be quite interesting.

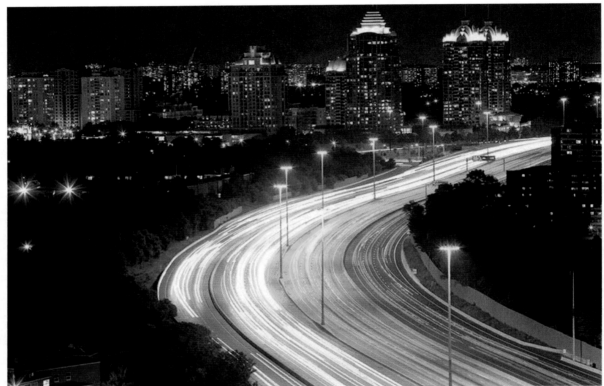

Kennymatic -- Wikipedia Commons

Making People Disappear

A long exposure – several minutes – with a small aperture can eliminate people on a busy street at night.

Imagine that you are traveling in a foreign country and you find a street that has great character – particularly at night with its dim street lamps. If you take a long enough exposure, people who walk down the street won't stay in one place long enough to register on the image. So even if the street is very busy, you can make it look deserted.

The same thing can sometimes be accomplished in daylight by using a very dark neutral gray filter. NG or Neutral Gray Filters are lenses that screw onto the front of your regular lens. They have no affect on the color of your image. They simply reduce the

amount of light coming through the lens. They can be purchased as fixed-density lenses or a variable-density lens that you rotate to get the desired reduction of light. The variable lenses usually have a range of 1 stop to 8 stops. In other words, they can have the same effect as stopping down the Aperture by the same number of stops. Fixed-density lenses are labeled in two different ways – either by Xs or stops. A 2X lens is the same as 1 stop, a 4X lens is the same as a 2 stop, 8X is the same as 3 stops, etc. These lenses can also be stacked for an even greater reduction in light.

Freeze Action

A Shutter Speed of 1/125 or faster will generally freeze action for people and animals. There is a limit to the speed based upon your intent. If you want to catch a race horse with all four feet off the ground, you will want a very high speed like 1/1000. The result is sometimes so unrealistic that a slower speed is chosen instead. Again it is a matter of artistic intent.

Portray Motion

Long exposures of the night sky clearly indicate the rotation of the earth.

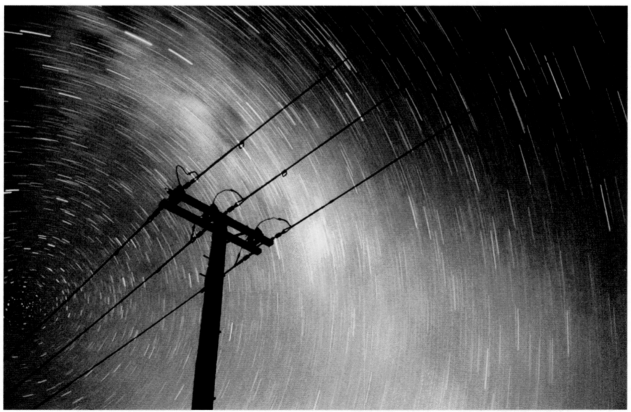

http://cameron-jung.deviantart.com/

ISO 100, f/4, 28mm, 22 minutes

More examples of motion at night. Things that are stationary will appear sharply focused while moving objects will create colorful blurs where ever there are lights. This is a result of a long exposure time – slow Shutter Speed.

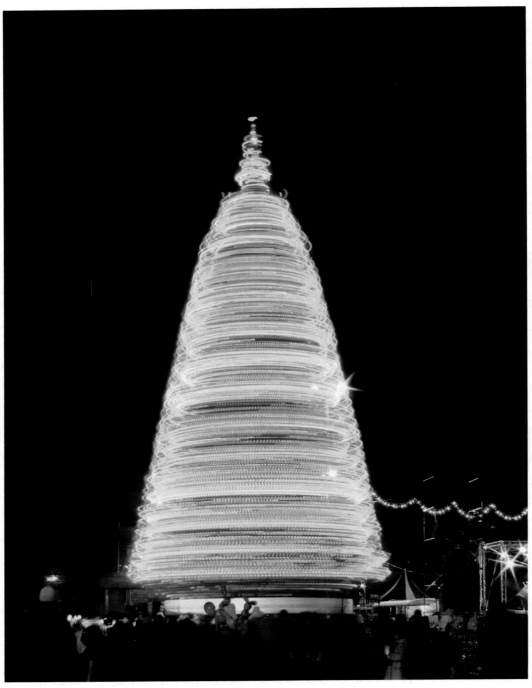

http://www.sxc.hu/profile/alexkalina

http://particle-fountain.deviantart.com/

Chapter Four – Understanding Exposure

Simply put, Exposure is the amount of light that reaches the Sensor. In Chapter One, we discussed how light travels through an Aperture and why the image might be sharp or blurred based on the Aperture size. Aperture is the first of two critical factors affecting **EXPOSURE**. The Exposure is also controlled by the shutter speed or how long the shutter stays open. We aren't used to thinking of light in terms of quantity, but that is what Proper Exposure is – the right ***Quantity of Light***.

It is easier for most of us to think about water when we talk about filling something, so imagine that we are filling a chamber around the sensor with water. The source of this water is a waterfall. Also imagine that the chamber has to be full but not overflowing in order to get a good picture. In this analogy, the Aperture is a hole in the top of the chamber and the Shutter is a cork. It is easy to see that the chamber will fill faster if the hole is larger. It is also clear that the cork has to be pulled out of the hole to start filling the chamber and replaced as soon as the chamber is full. Just like the waterfall, the sun provides much more light than what is needed to do the job. This is the essence of Exposure. The larger the hole or Aperture, the easier it is for light to get to the Sensor. When there is enough light, the Shutter must be closed immediately.

In-camera Exposure Meters measure the light reflected by the scene or object being photographed. They then calculate the Quantity of Light that is needed for Proper Exposure based on certain generic assumptions about the reflected light. If these assumptions are incorrect, the recommended Exposure will also be incorrect. We will talk more about this in the next chapter. For now, the thing to remember is that the light that falls on the object being photographed is a more accurate indication of Exposure than the light that it reflects back to the camera. We need a better way to determine the Proper Exposure and you will soon know what it is. First, we need to learn a little more about other methods of determining Proper Exposure.

Earlier, we defined Proper Exposure as the right Quantity of Light. Ordinarily this means the amount of light to produce a bright and vibrant image. For artistic purposes, a photographer might purposely choose more or less light in order to convey a feeling of excitement or gloom. This is why so many people will say that there is no such thing as Proper Exposure. Before you can break the rules with positive results, you have to master them. So for our purposes, I will continue using the term Proper Exposure to indicate the Quantity of Light that would result in a bright, vibrant, and sharp image.

Understanding the relationship between Aperture and Shutter Speed is critical to Understanding Proper Exposure as we have defined it. If you stop down a full stop and double the amount of time that the shutter is open, you have the ***Same Exposure***. The difference would be that you have a greater Depth of Field.

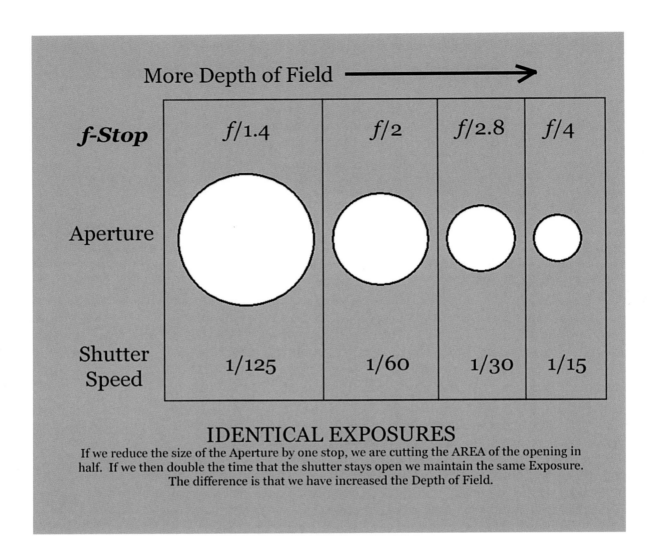

IDENTICAL EXPOSURES

If we reduce the size of the Aperture by one stop, we are cutting the AREA of the opening in half. If we then double the time that the shutter stays open we maintain the same Exposure. The difference is that we have increased the Depth of Field.

Proper Exposure

Your digital SLR has a built-in Exposure meter with a number of options. Since your exact options depend on your camera make and model, I would suggest that you consult your owner's manual for more on this topic, but for most cases the "evaluative" setting is the best choice. With this setting, the exposure meter evaluates the entire image and then makes its Shutter Speed selection based on that data.

Bright areas of a photo are called **HIGHLIGHTS**. Dark areas are called **SHADOWS** or **BLACKS**. Neutral areas are called **MID-TONES**. **HIGHLIGHT CLIPPING** means that the image has been exposed enough that details have been lost in the highlights. This is often the case with clouds. **SHADOW CLIPPING** is a loss of details in the shadows due to under-exposure.

With digital photography and software such as Lightroom and Photoshop, it is generally best to allow the shadow areas to remain dark and adjust the brightest areas so that

there is no Highlight Clipping and details are retained. For example, clouds are very bright but they often have a lot of interesting details – shades of gray and colors. If the image is over-exposed, this detail can be totally lost, so it is important to darken the exposure so that all of the detail in the clouds is retained. If this causes the shadows in the image to get darker, the contrast might punch-up the image. Also, there is a good chance that the shadow details can be recovered by software manipulation.

Gaging Proper Exposure

There are several ways to gage proper Exposure: The easiest is to allow the camera's built-in Exposure meter to decide for you. This is called **AUTO-EXPOSURE**. The only thing that you have to do is decide how your camera measures the light. The *Evaluative* setting is the most widely used. In this case, the meter evaluates numerous regions (35 regions for my camera) of the image and selects an exposure based on the overall average brightness. There are several other possible meter settings but this is a good starting place.

As you gain more skill, consult your manual to see if one of the other settings would be appropriate. For my camera, the other choices are *Partial Metering* based on the center of the image and about 9% of the total area, *Spot Metering* based on the center of the image and 3.8% of the total area, and *Center Weighted* – similar to Evaluative but with more emphasis on the center.

The actual settings that the camera has to choose for proper Exposure depend upon the shooting mode chosen at the time. If you are shooting in the Av mode, you will pick the Aperture setting and the camera will choose the Shutter Speed. Likewise, if you are shooting in Tv mode, you will pick the Shutter Speed and the camera will choose the Aperture setting (*f*-stop).

There is one more control that you have over auto-exposure. On your LCD screen, there is an **EXPOSURE COMPENSATION** gage. Normal exposure is in the middle, and you can move this setting by up to 2 full stops brighter or darker. Your camera menu will allow you to set the gage for 1/2 stop or 1/3 stop increments for finer control. With practice, you will soon learn when to apply Exposure compensation. For example, if you are trying to photograph city lights from a distance, most of the frame will be dark and the normal Exposure setting will result in large bright spots instead of finely focused lights. You need to darken the Exposure several stops so that the lights are not overexposed. With the Exposure Compensation gage, it is a simple matter of making a menu selection and rotating a dial. In this case, you are simply telling the In-Camera Exposure Meter that it has made some bad assumptions. It assumed that the average tonal value was much brighter than it really is. Of course, you could also Stop Down your Aperture, Shutter Speed or both. If you had initially selected a high ISO because of the low light situation, you could also choose a lower ISO setting at this point.

High Dynamic Range – HDR – Images

EXPOSURE BRACKETING is a common technique used by many photographers. With this technique, you set the camera to take a normal Exposure followed by a darker exposure and then a lighter exposure. The camera will then take three shots in rapid succession with one click of the shutter release button. A tripod and remote shutter-release are imperative for this technique since the software has to accurately align the three images. Even the slightest camera movement can make it impossible to align the images for processing.

There are two reasons for using this technique. If you have a tricky lighting situation and you are not quite certain of the best setting, you might want to take additional shots – both brighter and darker – and choose your best Exposure after the fact.

The other reason for Bracketing is to create **HDR** (High Dynamic Range) images. In this case, two or more exposures of the same object are combined by software to produce better overall exposure. The software selects the best exposed portions of each shot and combines them into one image.

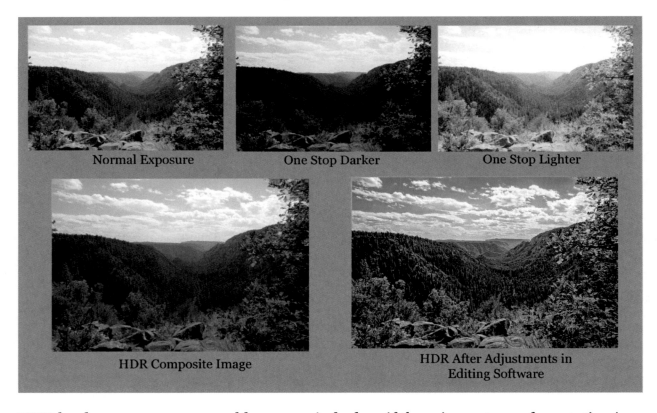

Normal Exposure One Stop Darker One Stop Lighter

HDR Composite Image HDR After Adjustments in Editing Software

HDR landscapes can cause problems on windy days if there is any type of vegetation in the foreground. Although the camera will take three exposures in rapid succession, tree leaves and small branches will move. These items will be blurred in the composite image. If you get lucky, the movement might convey a desired windy effect. In most cases it will just be a distraction.

Some photographers love HDR images and others avoid them at all costs. Many people process them in such a way that they look unnatural and sometimes grungy.

A variation of this technique is to take several exposures to emphasize different areas of the scene and then manually combine them using layer masks in Photoshop. This technique is beyond the scope of this book but deserves a little discussion. In the previous example, I would take a shot that perfectly exposes the sky and ignore the rest of the image. I would then take a shot that perfectly exposes the foreground and finally a shot that perfectly exposes the details of the canyon. I would then paint over or mask all but the perfectly exposed areas in each photo. Finally, I would combine the three images in a program like Photoshop, thus producing an image that shows all the details perfectly exposed.

Exposure Zones

Another method of evaluating exposure is to use a hand-held exposure meter and the **EXPOSURE ZONES** technique. This system was developed by Ansel Adams and Fred Archer. The Zones are denoted by Roman numerals and range from 0 to X. The middle zone is Zone V (5) and represents mid-tones. Zone VI is one stop brighter and Zone VII is two stops brighter. Zone IV is one stop darker than V and Zone III is two stops darker than V. In digital photography, blacks are considered Zone II and pure whites are considered Zone VIII. Thus only 7 of the 11 original Zones are used. In its simplest form, an image should be observed and evaluated as to what percentage of the overall image falls into each Zone and then use an exposure setting that works for most of the image without Highlight Clipping.

To Learn more, click <u>Ansel Adams & Fred Archer's Zone System</u>

Histograms

A third method of evaluating Exposure is the **HISTOGRAM**. This is basically a chart that shows how much of the image falls in each wavelength of light from pure black on the left to pure white on the right. With digital photography, there is no ideal histogram but you should avoid clipping of shadows and highlights, with highlight clipping being the most important.

If you draw a vertical line anywhere on the histogram it represents a shade of grade or **TONAL VALUE**. If this were a black & white image it would be described as a shade of grey. In color photography, tonal value is probably more accurate. For any given vertical line, the height of the grey histogram indicates how much of the image is at that exact tone. The height of the green indicates how much of the green histogram is in that tone. The same is true of red and blue. For this particular image we see that more of the image is dark than light. This does not necessarily mean that the image is

underexposed. The more you read histograms the more they will tell you. Practice definitely makes a difference in this case.

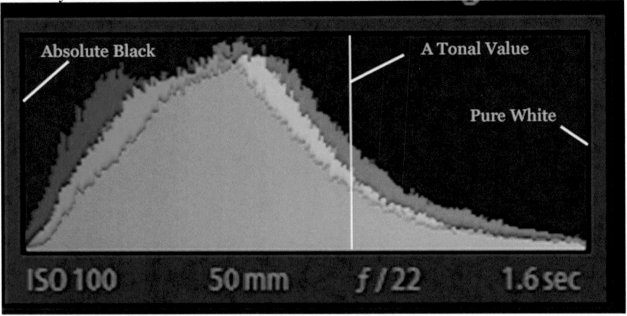

The following figure illustrates the relationship between the Histogram, your camera's Exposure Compensation, and the Zone System of exposure developed by Ansel Adams and Fred Archer.

The far left edge of the Histogram represents pure black. The far right represents pure white. The height of the curve at any point represents how much of the image data is represented by that particular frequency or color. This histogram is actually four histograms in one. The gray area represents the range where Red, Green, and Blue overlap. The color fringes represent overlaps of two of the primary colors or a single primary color.

Histogram

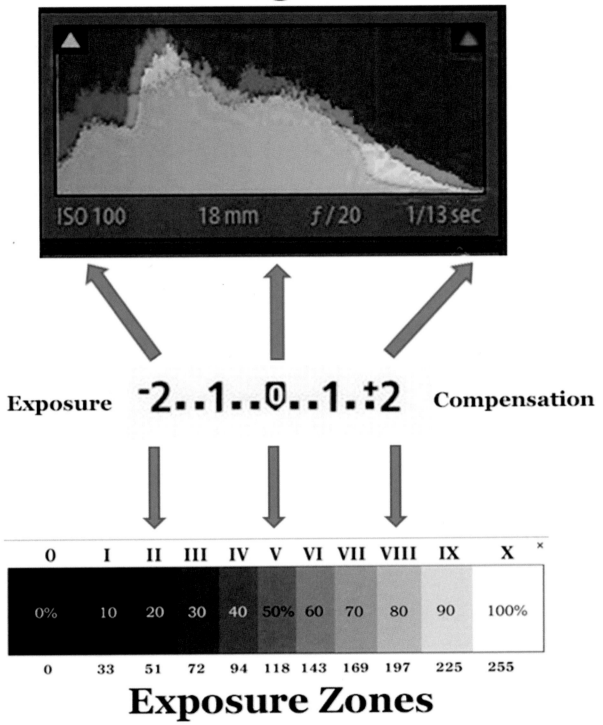

Exposure -2..1..0..1.+2 Compensation

0	I	II	III	IV	V	VI	VII	VIII	IX	X	×
0%	10	20	30	40	50%	60	70	80	90	100%	
0	33	51	72	94	118	143	169	197	225	255	

Exposure Zones

For digital photography, the histogram should taper off on the right side as shown here. This means that the highlights have not been clipped and that all the highlight detail is available for editing. The height of the curve on the left in this histogram indicates that some of the shadow details have been clipped. This is a reasonable trade-off in order to be certain that the highlights have not been clipped.

Clipped highlight details cannot be recovered by editing software. Clipped shadow details, on the other hand, can often be recovered with editing software.

Digital photography only uses seven of the eleven zones of the Zone System.

Chapter Five – Putting It All Together

Overview

In case you didn't notice, everything that affects exposure is set up in One-Stop increments. This makes it much easier to make tradeoffs.

Adjustment	Initial Value	One Stop	Two Stops	Three Stops	Four Stops
Aperture	$f/1.4$	$f/2.0$	$f/2.8$	$f/4.0$	$f/5.6$
Shutter Speed	1/500	1/250	1/125	1/60	1/30
ISO	100	200	400	800	1600
Exposure Compensation	-2	-1	0	+1	+2

Increase Exposure – More Light – Brighter Image →

← Decrease Exposure – Less Light – Darker Image

The first three adjustments are part of the Exposure Triangle. Exposure Compensation is actually a way of fine tuning your camera's built-in exposure meter. It is also an easy way to get multiple exposures for HDR images.

Why Is Adjusting Exposure So Important

As you develop your photographic skills, there will come a day when you realize that you have become obsessed with light and how it illuminates objects and scenes. You won't be able to watch a movie without noticing shadows that don't belong in the picture or the glow of the light on people's faces. Wherever you go and whatever you do, you will be constantly aware of the quality of the light around you and how it makes you feel. You will begin to notice little details in things and think about how a little light here or there would enhance that detail. You will begin to notice texture and contrast. All of these things are a result of just paying attention to something that you have taken for granted your entire life.

Once you reach this level of awareness, you will want your images to convey what you saw, felt, and were inspired by. The electronics of digital cameras will get you in the ballpark, but having the ability to fine-tune the settings will take your work to a whole new level. No camera in the world can balance Highlights and Shadows with the precision of the human eye. Cameras don't feel, so they miss the subtleties of soft or harsh lighting.

Just think about how many things affect the light that is ultimately recorded by your camera.

Light Intensity – this can be from the sun or artificial light, but this is the starting point.

Consistency or Duration – A totally overcast day provides diffuse light that enhances colors, but a partially cloudy day can cause dramatic and sudden changes in lighting.

Reflected Light – this manifests in several ways. How reflective is the subject of the photo? Are there surfaces nearby that reflect light on your subject? Can you use a reflective surface to enhance the light on the object?

Amount of light that actually passes through the lens. If you use any type of filter – especially NG Filters – you are reducing the intensity of the light.

Shutter Speed and Aperture – as we have been discussing, this regulates the Amount of Light that gets to the sensor.

Finally, we have the sensor itself and its *ISO setting* or relative sensitivity.

With so many variables, why let the camera have all the fun?

Incident vs Reflected Light

The light coming from the sun is full-spectrum light. In other words, it contains all wavelengths of light.

When sunlight strikes an object, many wavelengths are absorbed by the object while others are reflected.

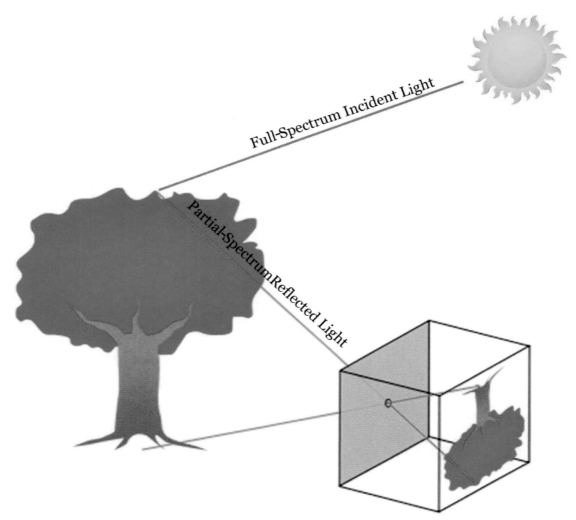

Wikipedia Commons Image Modified by Al Judge

The built-in light meter in cameras measures the reflected light and tries to make assumptions about the exposure based on reflected light only.

If the object being photographed is white like snow, the meter will under-expose it — making it darker than it really is. Likewise, if the subject is a black cat, the meter will over-expose it — making it lighter than it really is. This is because the meter assumes that the scene's average value of reflected light is 18% grey. If the scene does not fit this assumption, the exposure will be off.

A more accurate way to measure the light is to use an INCIDENT LIGHT METER. This type of meter measures the light that is striking the object rather than the light reflected by the object. These meters range from $80 to $800, so some research is required if you decide to take this extra step.

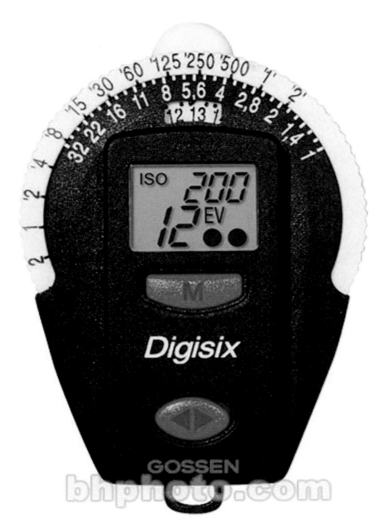

The image above is just one of many meters available from bhphoto.com. They also have a tutorial about light meters on their site. This particular meter can be purchased for about $150.

Basically, you set your ISO – in this case 200 – and point the meter at the light source. It then shows a value – in this case 12. You then rotate the White outter wheel until 12 is centered in the small window above the screen. This then matches Shutter Speeds with *f*-stops.

In this photo, f/16 matches 1/30 and f/4 matches 1/500. Every matched pair produces the same exposure.

The Best Way to Set Exposure

This section title is a bit of tongue-in-cheek. Everybody agrees that proper exposure is critical to good photography, but opinions and techniques are too numerous to even list. Personally, I use the histogram as an indicator more often than anything else, but I have just purchased an "Expodisc" that seems to work really well. It is a disc that you place over the front of your lens much as you would with a filter. You then point it at the source of INCIDENT LIGHT and snap a photo. This image is then used to adjust exposure and correct color. I will not go into detail about it here since the explanation is quite involved and I don't have a lot of experience with it yet. My main point is that you need to find something that works for you. We have discussed several popular ways to measure and adjust exposure. It is now up to you to decide how to use that information.

Histogram Examples

The image below is overexposed and parts of the clouds are blown out. That is, they have no image details – just bright white areas. This condition is called **Highlight Clipping**.

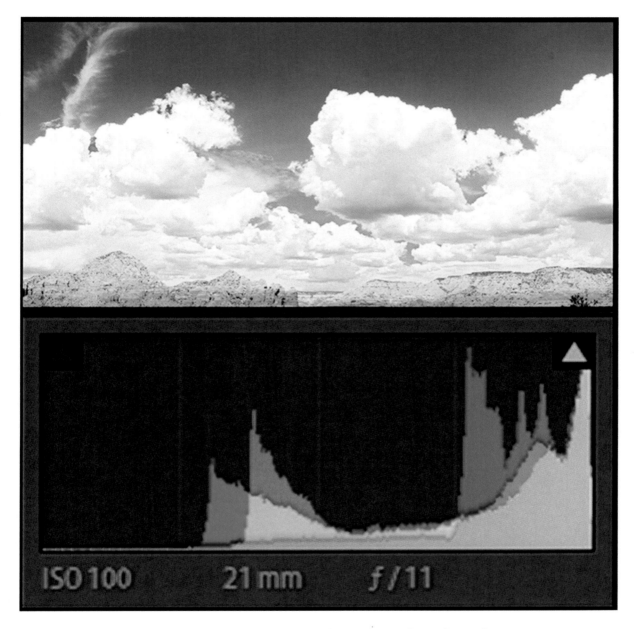

The Histogram for this image is bunched up along the right side. This is a sure indication of **Highlight Clipping** or "blow out."

The Image below is underexposed. Although we can now see details in the clouds, the image is clearly too dark.

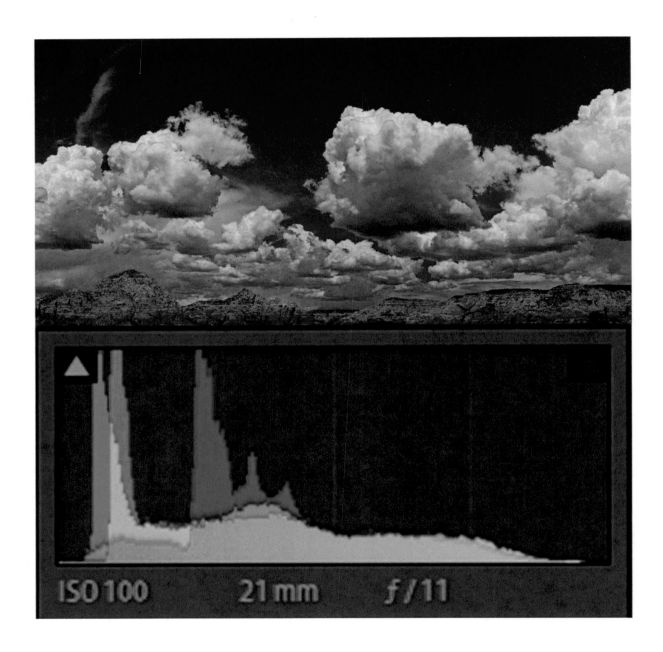

The Histogram for this image is strongly biased toward the left but is not bunched up along the left edge. This indicates that the image is underexposed but that the shadows have not been clipped. Thus there is no loss of image data, and proper exposure can be achieved by editing software such as Photoshop or Lightroom.

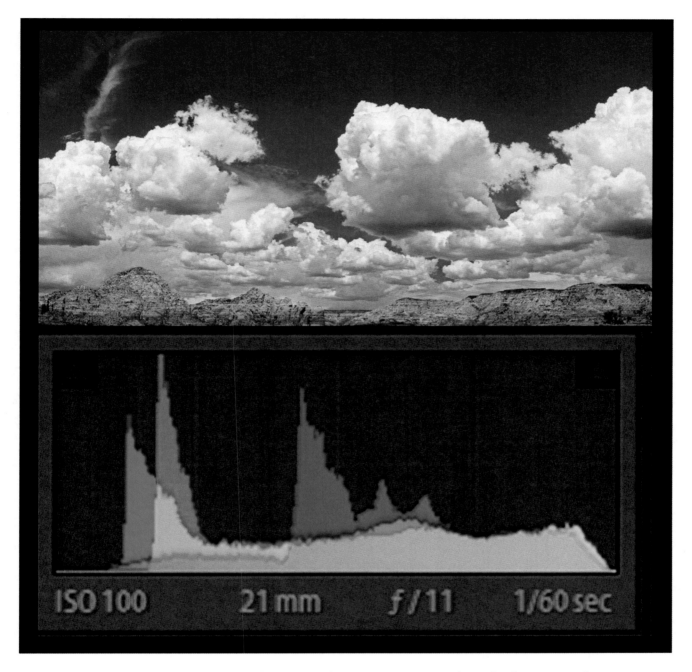

This Histogram indicates a properly exposed image. It is not bunched up on either side.

The Histogram is a great way to check your exposure.

The Exposure Triangle in Action

I think a few examples might help to clarify the tradeoffs in setting Exposure.

In this first example, we have a number of challenging conditions. These bushes grow along the side of a dry creek bed and in the shade. The terrain is rocky and fairly vertical making it difficult to position a tripod close to the bush. This condition makes the telephoto zoom lens a logical choice since I can set up several feet from the plant and zoom in. I decided to give it a shot with my 50mm fixed-focal length lens instead since this lens produces the sharpest image of my three lenses. With some effort, I was able to find a spot for the tripod and began planning my shot. I could have focused on a single spiral but wanted to show the fact that the bush was coverd with this new growth. Since I wanted to take in a fair amount of detail, I chose an Aperture setting of $f/8$. This will blur the background in a closeup image while giving a reasonable Depth of Field.

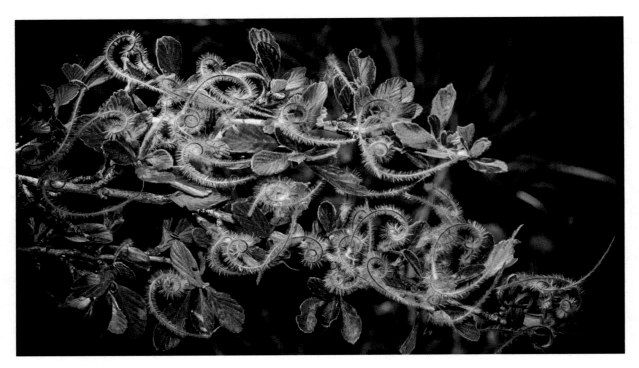

These bushes move with a breath of air and it was fairly breezy that day so I knew that I would need a fast Shutter Speed. I started with 1/250 sec, but the image was underexposed. I then started increasing the Aperture size. Even though this added light to the image, I didn't have enough depth of field. I then started increasing the ISO so that the sensor would be more sensitive to light and require less exposure time. The ISO helped, but I didn't want to go beyond ISO 800 because of the graininess that it produces. I was now at ISO 800 and 1/500 sec and still didn't have the image that I wanted. Though I rarely use a flash, this situation seemed to call for it. So I added some flash fill to the image.

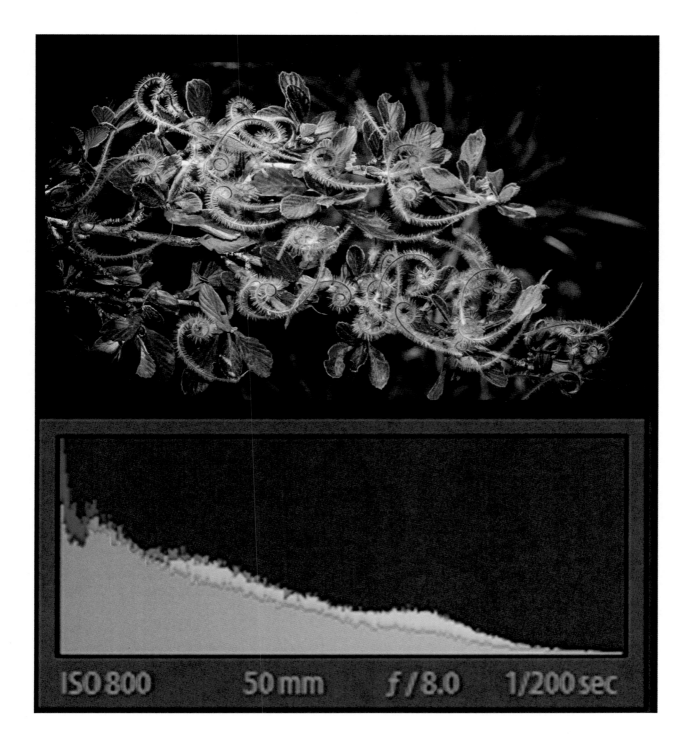

ISO 800 50 mm *f* / 8.0 1/200 sec

In this case the Histogram is bunched up against the left edge, but this is ok since we really don't care about the details in the shadows. This is an example of **SHADOW CLIPPING**.

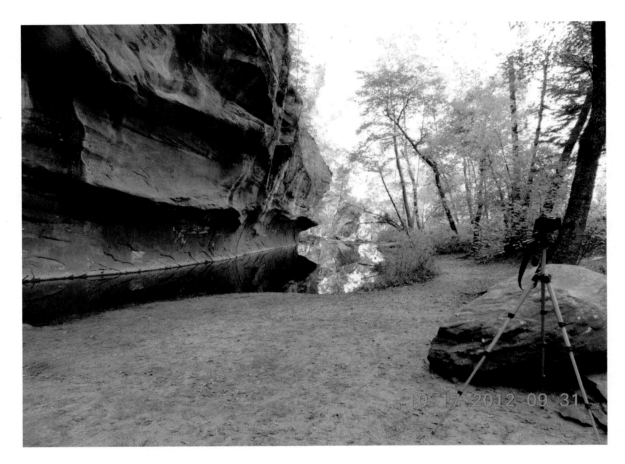

The image above was taken with a point-and-shoot camera just to document the location and conditions of the shoot. It offers several valuable lessons. First note that the camera's exposure meter wasn't up to the task in this case. This image contains significant **Highlight Clipping**.

With such intense and harsh light in the upper right quadrant, it would be very difficult to get a balanced shot. This is a typical application for HDR images, but I chose to do something different. Note that the rock wall on the left is totally in the shade and that my camera and tripod are also in the shade. Shade is a very diffused and soft light that brings out the color in things.

With these things in mind, I started my shoot with the canyon wall.

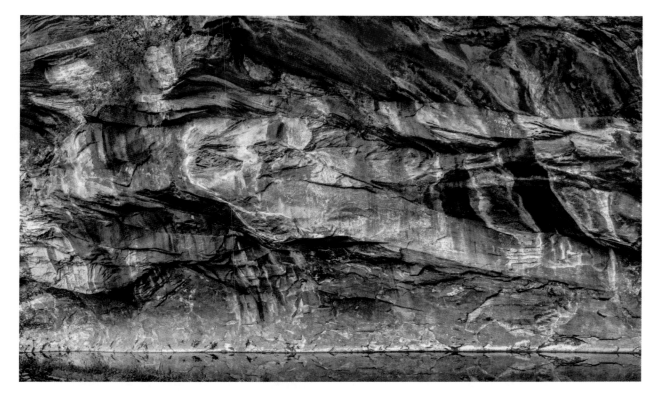

Since nothing in the image was going to move, I didn't care about exposure time – Shutter Speed – at all. I had a tripod and a remote shutter release so there was no need to rush the shot. I also wanted the sharpest image that I could get, so I chose my 50 mm lens and an $f/22$ aperture setting. I could have used almost any aperture in this case since I didn't need a lot of Depth of Field but I wanted a smaller aperture in order to be certain that the texture and details would show. I'm not sure that this was necessary, but it is definitely a personal preference. As you can see from the Histogram, this image was evenly and properly exposed with a shutter speed of 1.6 seconds.

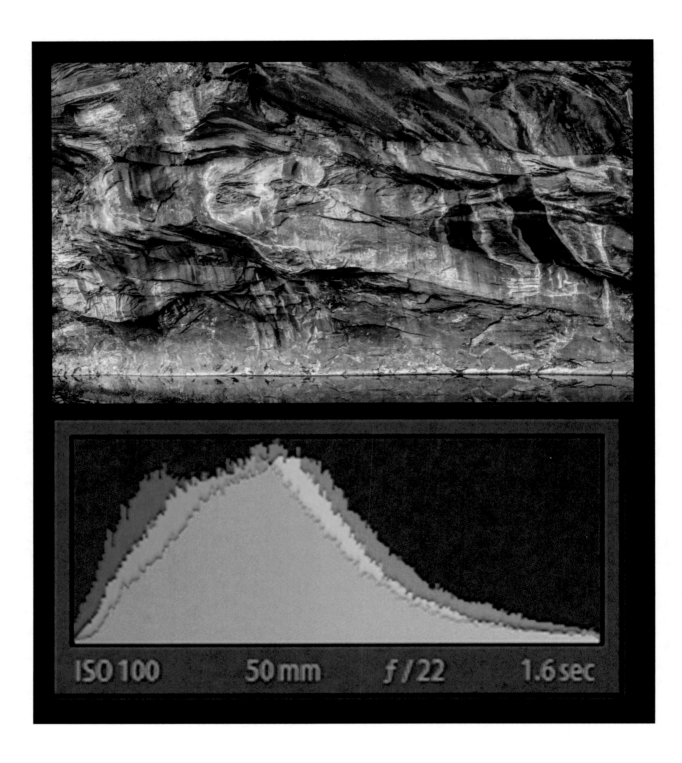

ISO 100 50 mm f /22 1.6 sec

The point-and-shoot image that we looked at earlier was taken at 9:30 AM.

I know this spot fairly well and knew that the light would be less harsh after Noon. At this time of year (October), the entire canyon is in shade by about 3:00 PM. With this in mind, I returned to the spot a little after Noon and captured the image below.

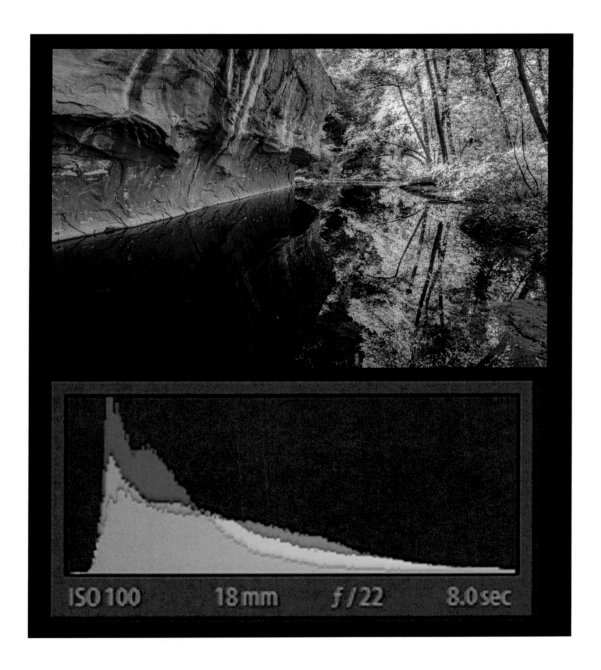

Although the reflection of the canyon wall is clear in the image, it is rather dark. This is why the histogram is biased to the left. Since it does not actually touch the left margin, we would expect to see some detail in the shadows. This is, in fact, the case.

Notice the Highlight Clipping in the Histogram for the image below. This is because I used an artistic edge that leaves a bit of a white border around the photo and has nothing to do with the actual exposure.

In time you will learn to read your histograms with more understanding. One thing to remember is that there is no such thing as a perfect or ideal histogram. If you just pay attention to **Highlight Clipping**, you are most of the way there.

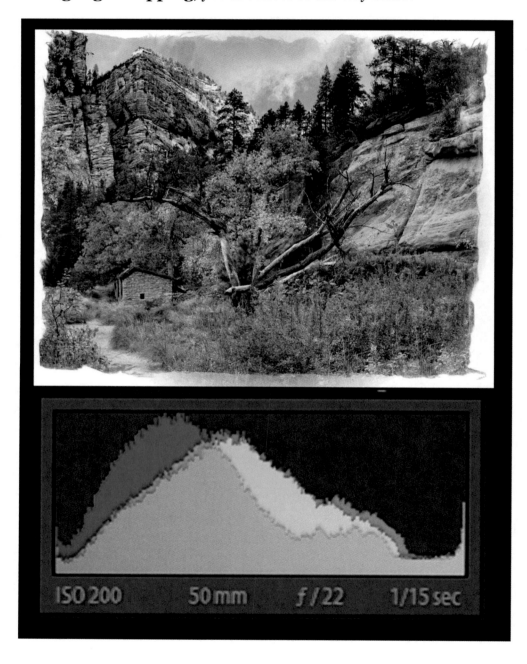

ISO 200 50 mm ƒ /22 1/15 sec

I hope that I have been successful in my desire to save you a lot of time and effort in your quest for creating better images. Any feedback would be greatly appreciated. Just send an email to ajudex@hotmail.com with "eBook feedback" in the subject line.

I am planning on writing several more books on photography. If you would like to know when they are available, send me an email with "Photo Books" in the subject line. I will let you know when they are published. I would also be interested in knowing which photographic topics might be of interest to you. I will not use your email address for any other purpose.

On-line reviews are greatly appreciated. If you liked the book and rate it well, others will be more inclined to read it. On the other hand, if you had issues with the book, that information is equally as important. That information will help me do a better job next time.

Thanks for taking the time to read *Mastering Aperture, Shutter Speed, ISO and Exposure*

Al Judge
www.aj-foto.com
ajudex@hotmail.com

You might also find my first Photography Book of some interest.

http://tinyurl.com/asm7la9

To see all my books please go to my Author Page at http://tinyurl.com/aq67c77

Made in the USA
Middletown, DE
10 November 2020